Color By Number Adult Coloring Book of Winter Animals

This Winter Animals Coloring Book belongs to:

Copyright © 2019 Winter Animals Coloring Books

1. Black
2. Green
3. Blue
4. Brown
5. Purple
6. Light Blue
7. Light Green
8. Orange
9. Dark Red
10. Pink
11. Red
12. Dark Green
13. Gold
14. Violet
15. Yellow

1. Red
2. Green
3. Blue
4. Brown
5. Purple
6. Light Blue
7. Light Green
8. Orange
9. Dark Red
10. Pink
11. Black
12. Dark Green
13. Gold
14. Violet
15. Yellow

1. Red
2. Green
3. Blue
4. Brown
5. Purple
6. Light Blue
7. Light Green
8. Orange
9. Dark Red
10. Pink
11. Black
12. Dark Green
13. Gold
14. Violet
15. Yellow

1. Red
2. Green
3. Blue
4. Brown
5. Purple
6. Light Blue
7. Light Green
8. Orange
9. Dark Red
10. Pink
11. Black
12. Dark Green
13. Gold
14. Violet
15. Yellow

1. Black
2. Green
3. Blue
4. Brown
5. Purple
6. Light Blue
7. Light Green
8. Orange
9. Dark Red
10. Pink
11. Red
12. Dark Green
13. Gold
14. Violet
15. Yellow

1. Black
2. Green
3. Blue
4. Brown
5. Purple
6. Light Blue
7. Light Green
8. Orange
9. Dark Red
10. Pink
11. Red
12. Dark Green
13. Gold
14. Violet
15. Yellow

1. Black
2. Green
3. Blue
4. Brown
5. Purple
6. Light Blue
7. Light Green
8. Orange
9. Dark Red
10. Pink
11. Red
12. Dark Green
13. Gold
14. Violet
15. Yellow

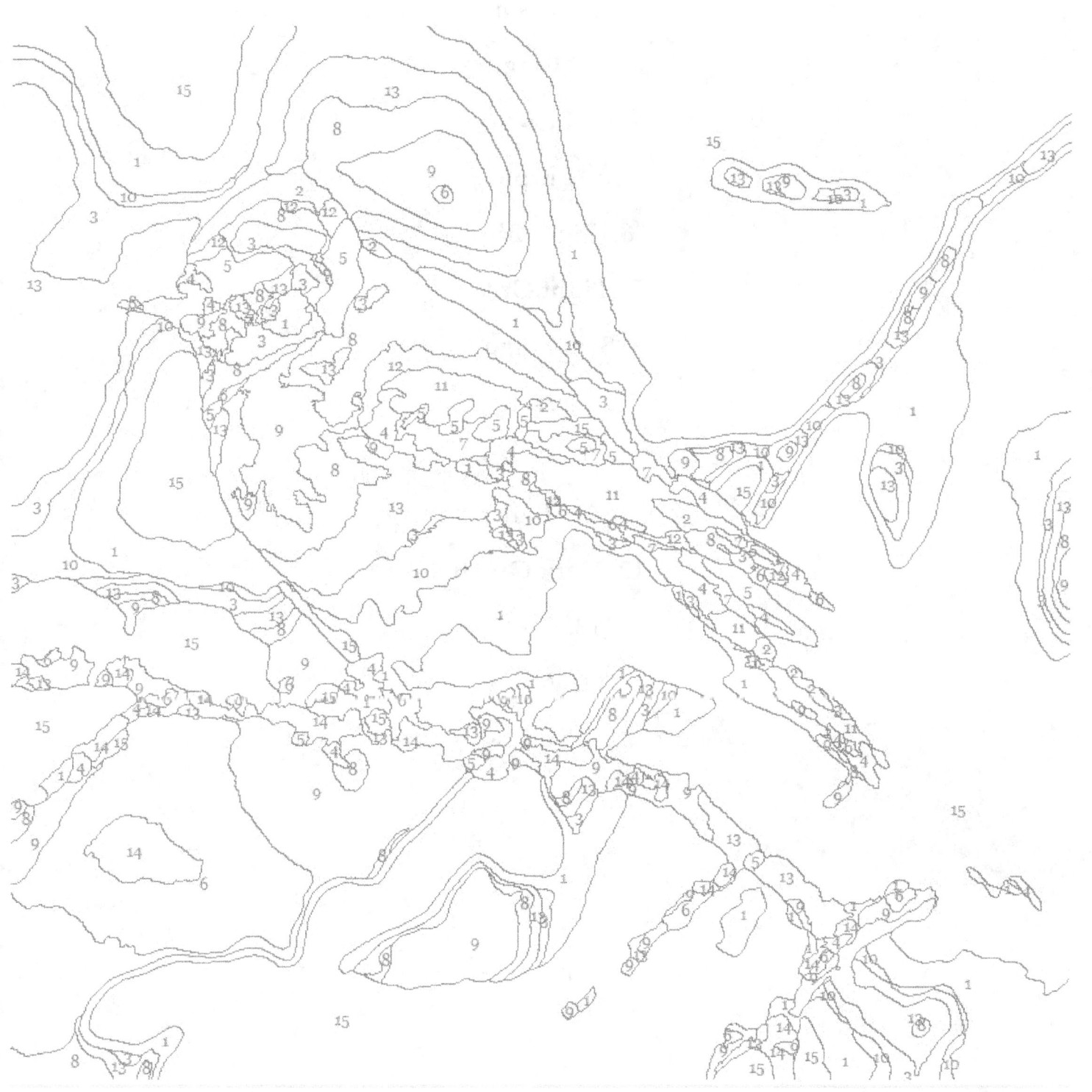

1. Black
2. Green
3. Blue
4. Brown
5. Purple
6. Light Blue
7. Light Green
8. Orange
9. Dark Red
10. Pink
11. Red
12. Dark Green
13. Gold
14. Violet
15. Yellow

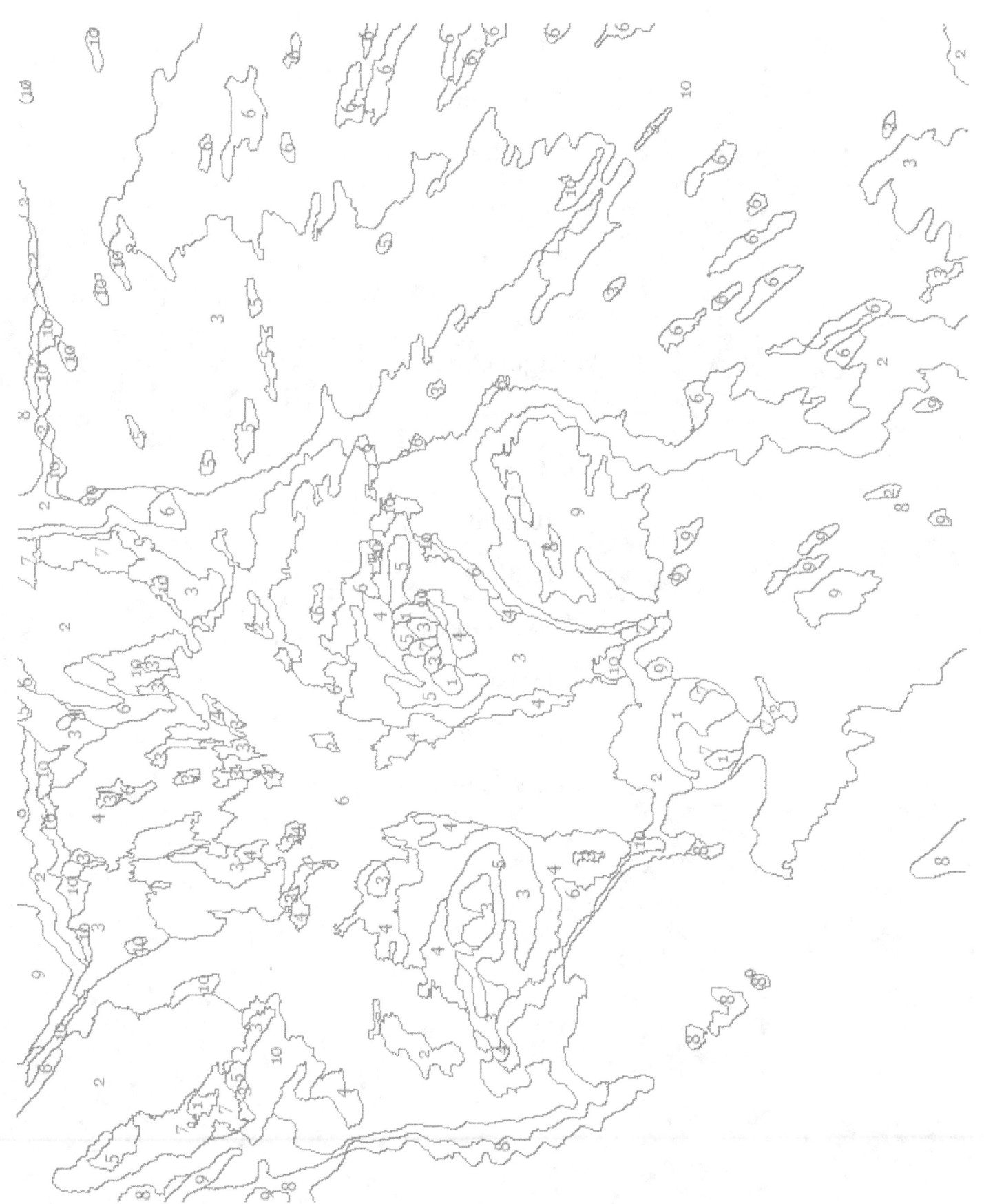

1. Red
2. Green
3. Blue
4. Brown
5. Purple
6. Light Blue
7. Light Green
8. Orange
9. Dark Red
10. Pink
11. Black
12. Dark Green
13. Gold
14. Violet
15. Yellow

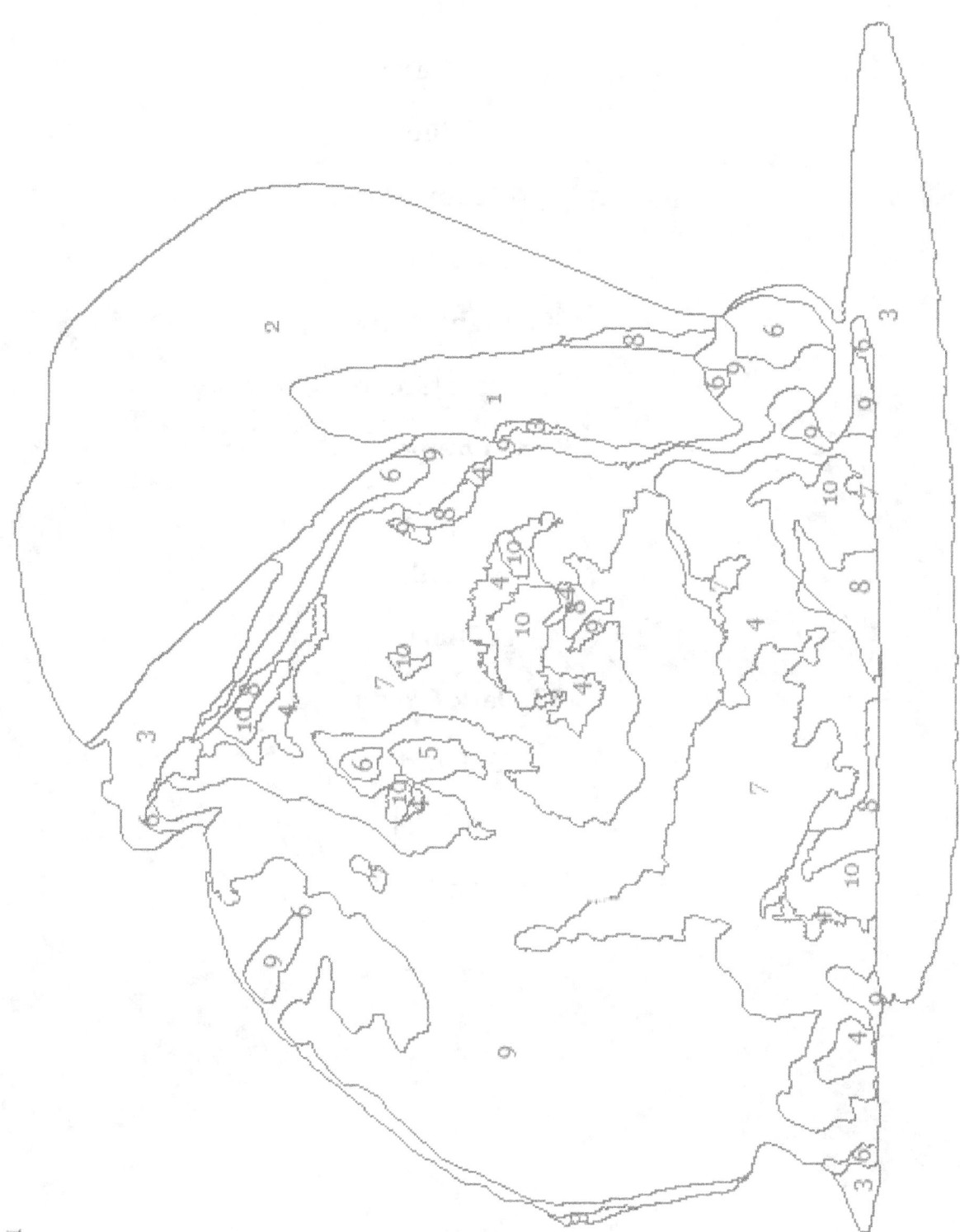

1. Red
2. Green
3. Blue
4. Brown
5. Purple
6. Light Blue
7. Light Green
8. Orange
9. Dark Red
10. Pink
11. Black
12. Dark Green
13. Gold
14. Violet
15. Yellow

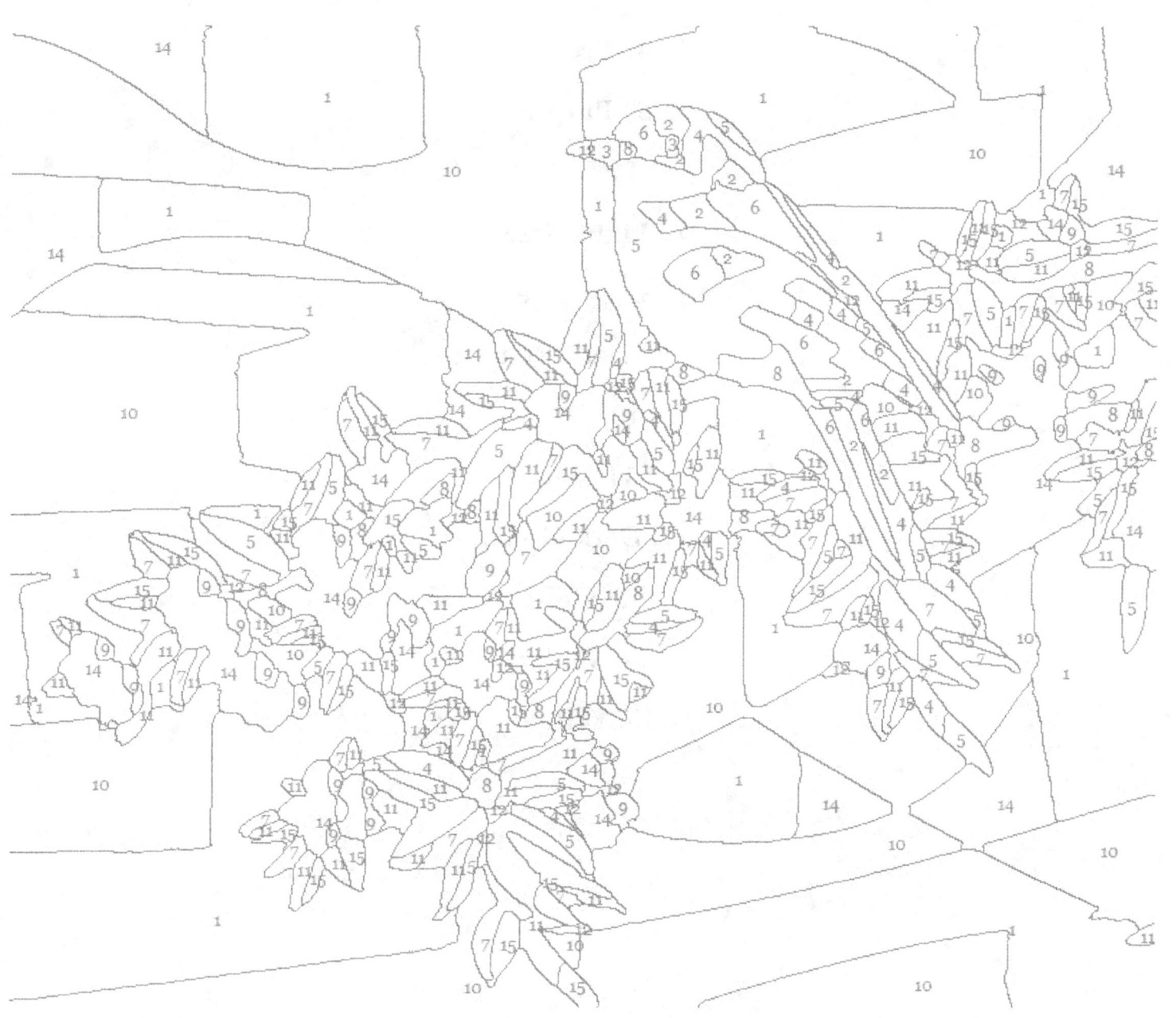

1. Black
2. Green
3. Blue
4. Brown
5. Purple
6. Light Blue
7. Light Green
8. Orange
9. Dark Red
10. Pink
11. Red
12. Dark Green
13. Gold
14. Violet
15. Yellow

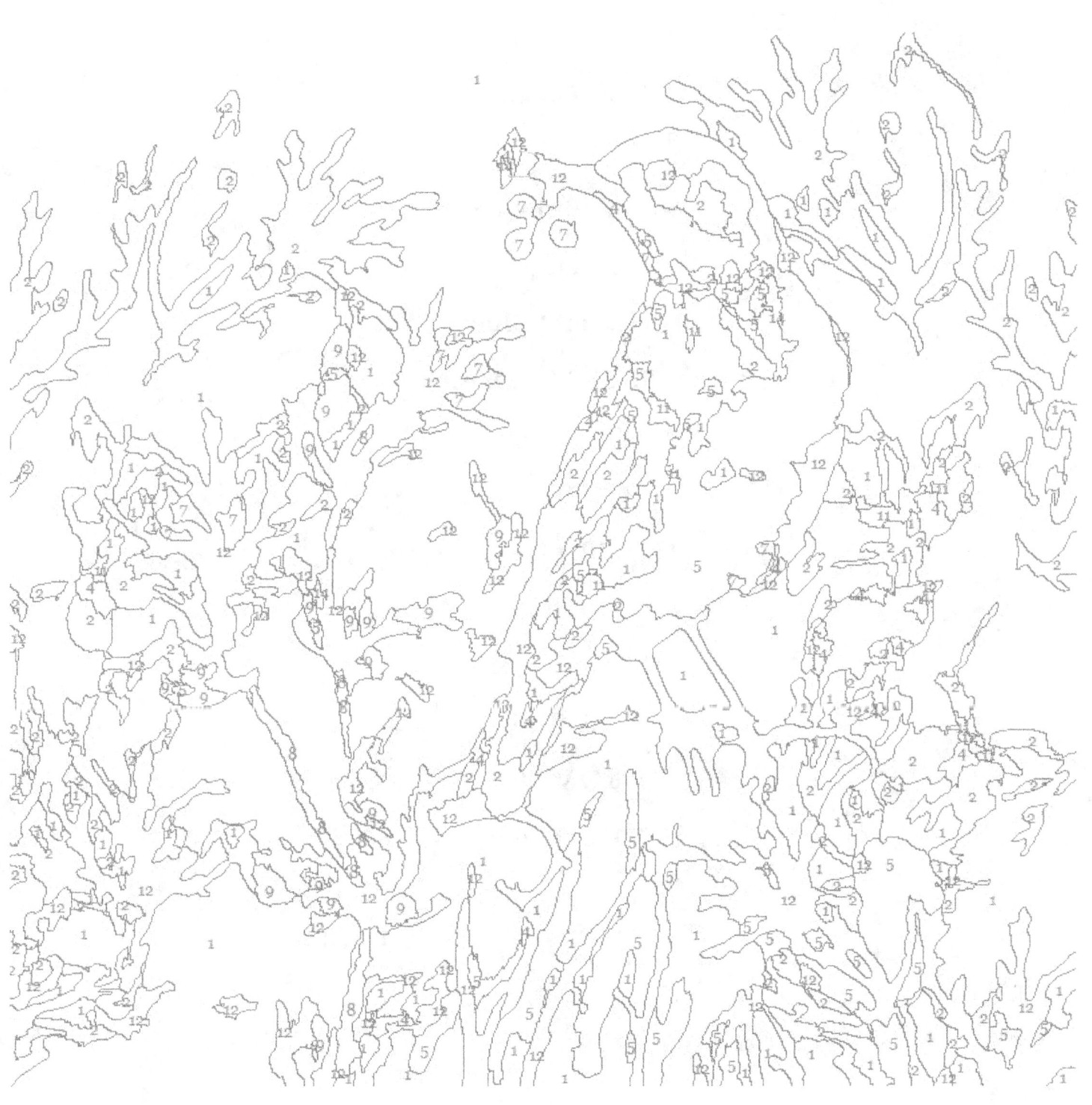

1. Black
2. Green
3. Blue
4. Brown
5. Purple
6. Light Blue
7. Light Green
8. Orange
9. Dark Red
10. Pink
11. Red
12. Dark Green
13. Gold
14. Violet
15. Yellow

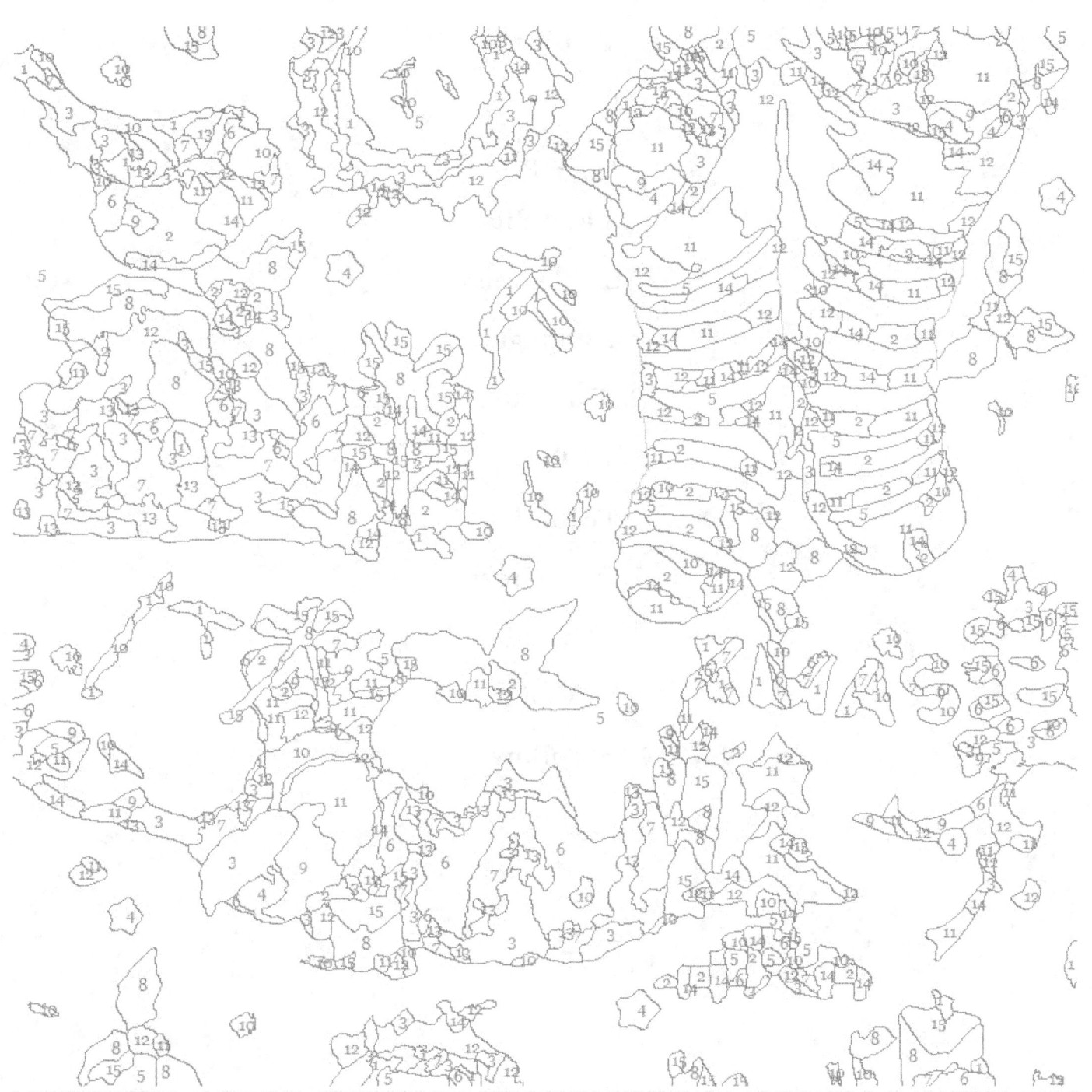

1. Red
2. Green
3. Blue
4. Brown
5. Purple
6. Light Blue
7. Light Green
8. Orange
9. Dark Red
10. Pink
11. Black
12. Dark Green
13. Gold
14. Violet
15. Yellow

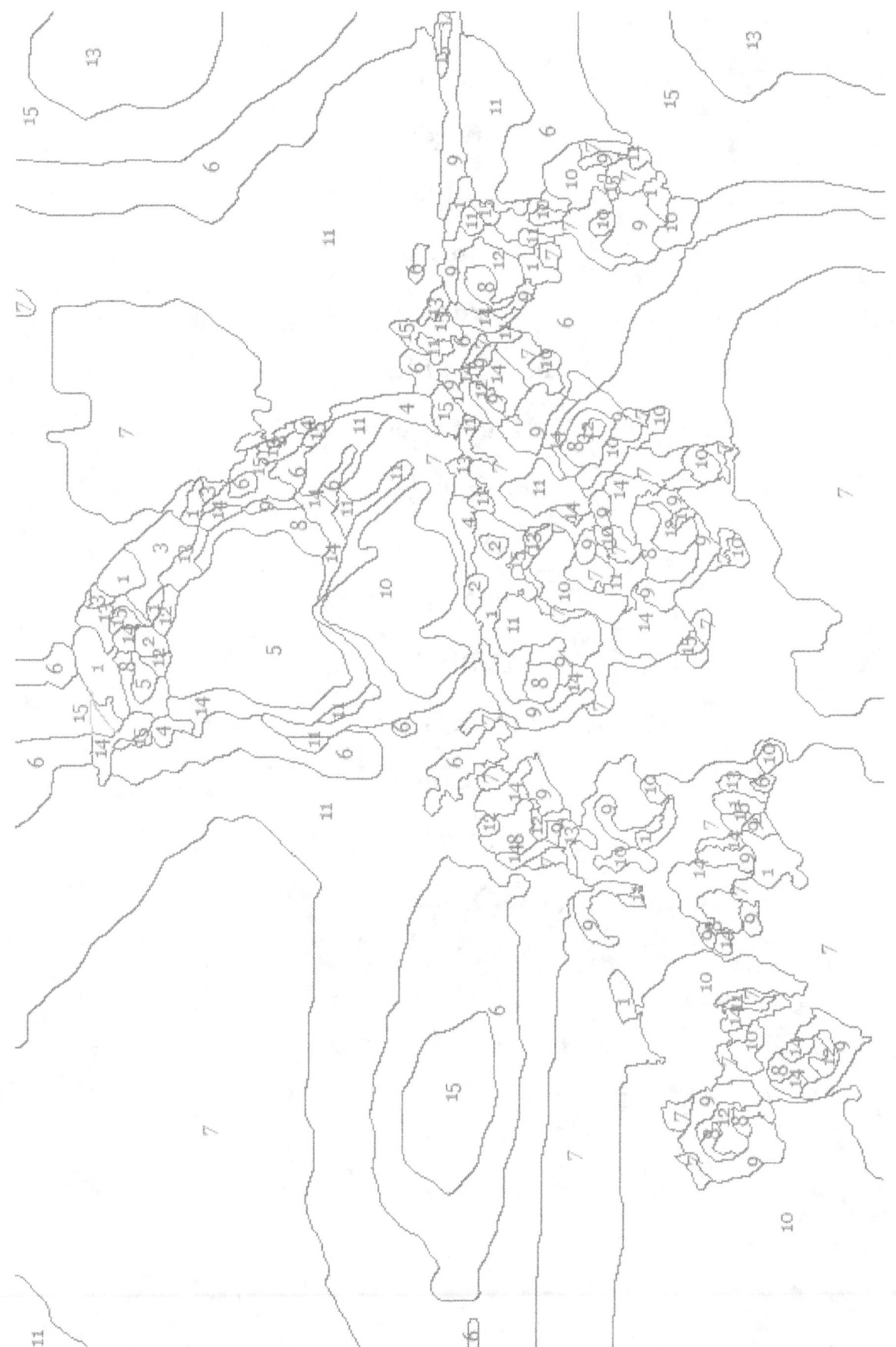

1. Red
2. Green
3. Blue
4. Brown
5. Purple
6. Light Blue
7. Light Green
8. Orange
9. Dark Red
10. Pink
11. Black
12. Dark Green
13. Gold
14. Violet
15. Yellow

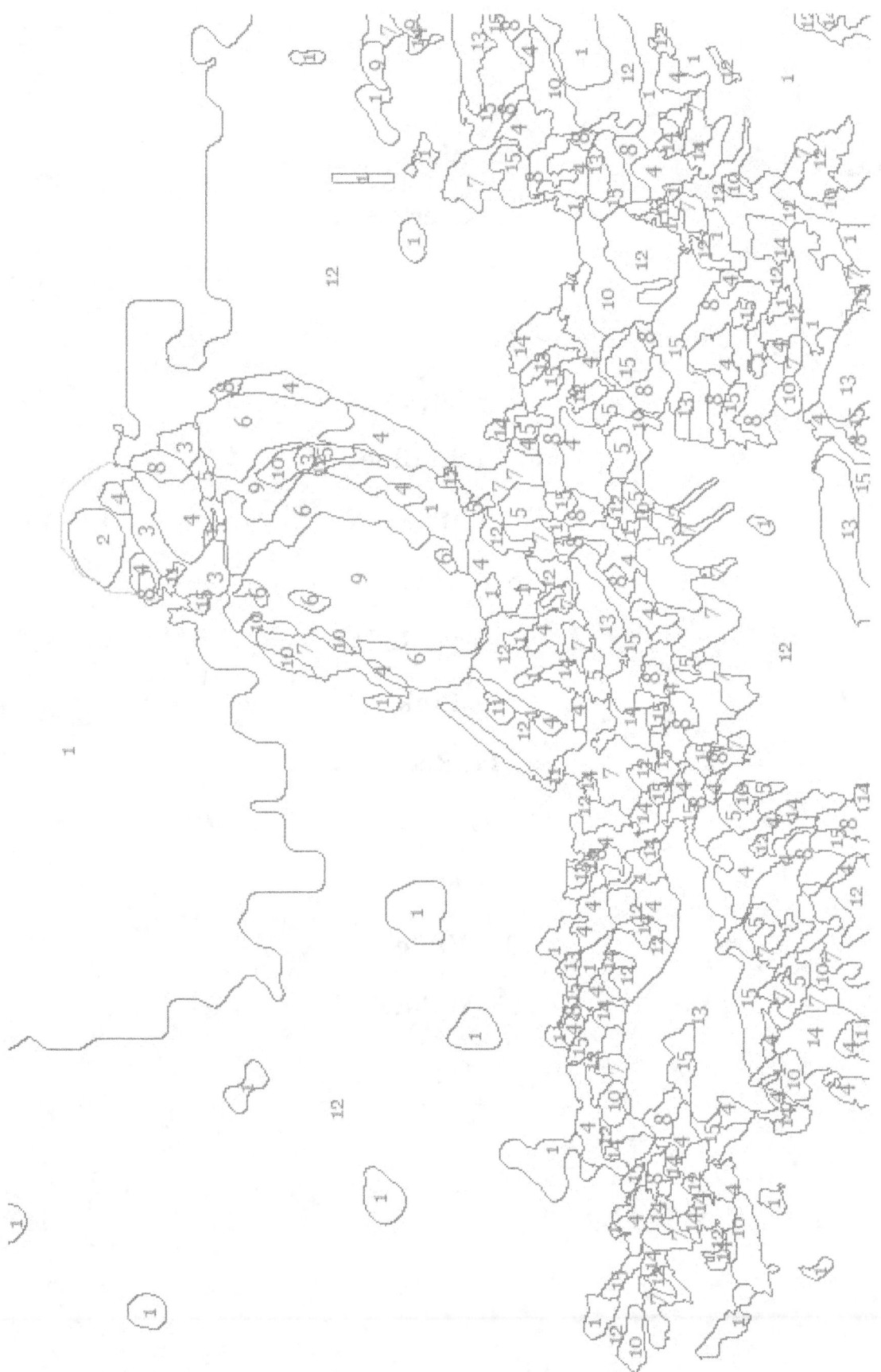

1. Black
2. Green
3. Blue
4. Brown
5. Purple
6. Light Blue
7. Light Green
8. Orange
9. Dark Red
10. Pink
11. Red
12. Dark Green
13. Gold
14. Violet
15. Yellow

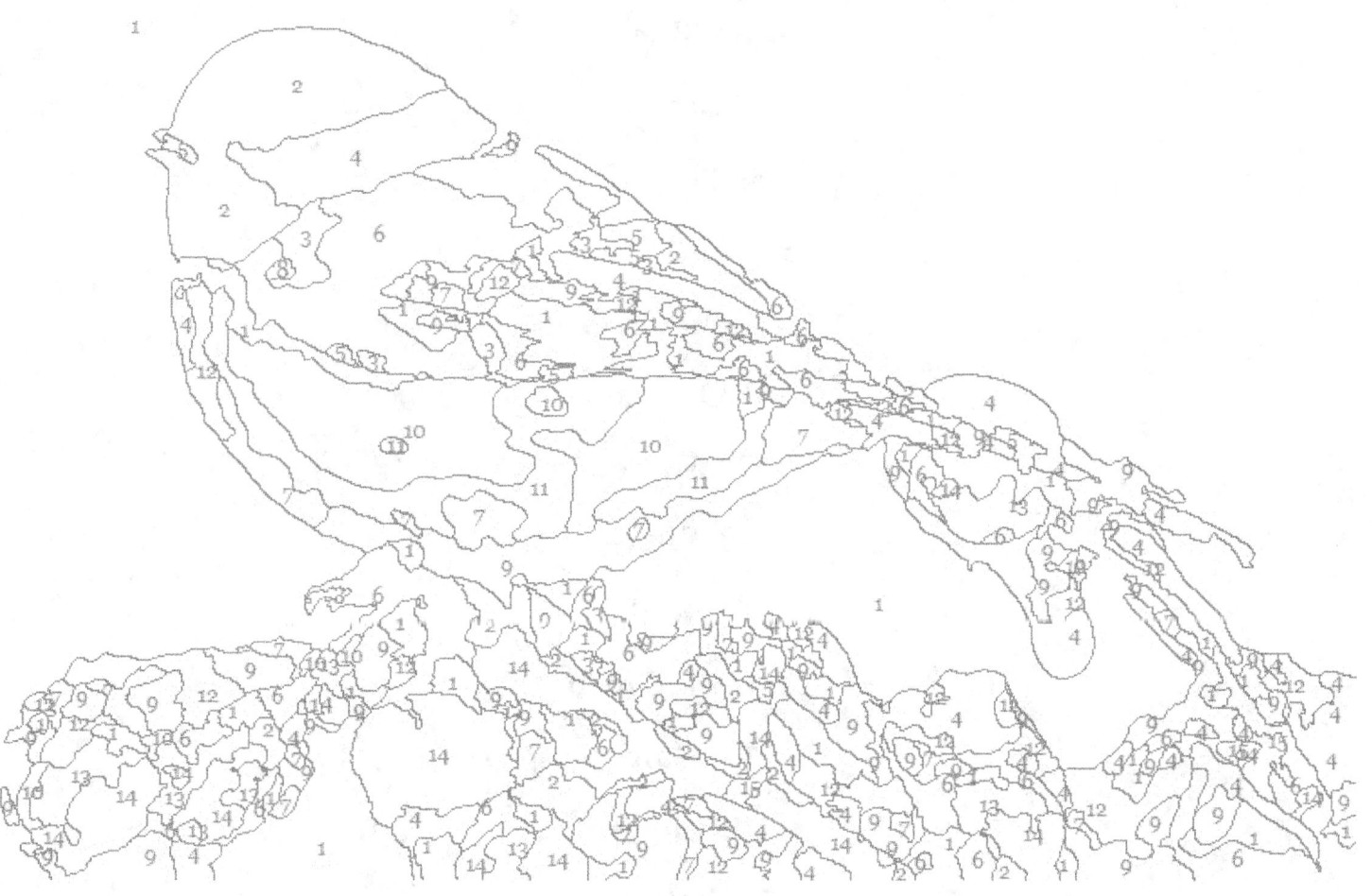

1. Black
2. Green
3. Blue
4. Brown
5. Purple
6. Light Blue
7. Light Green
8. Orange
9. Dark Red
10. Pink
11. Red
12. Dark Green
13. Gold
14. Violet
15. Yellow

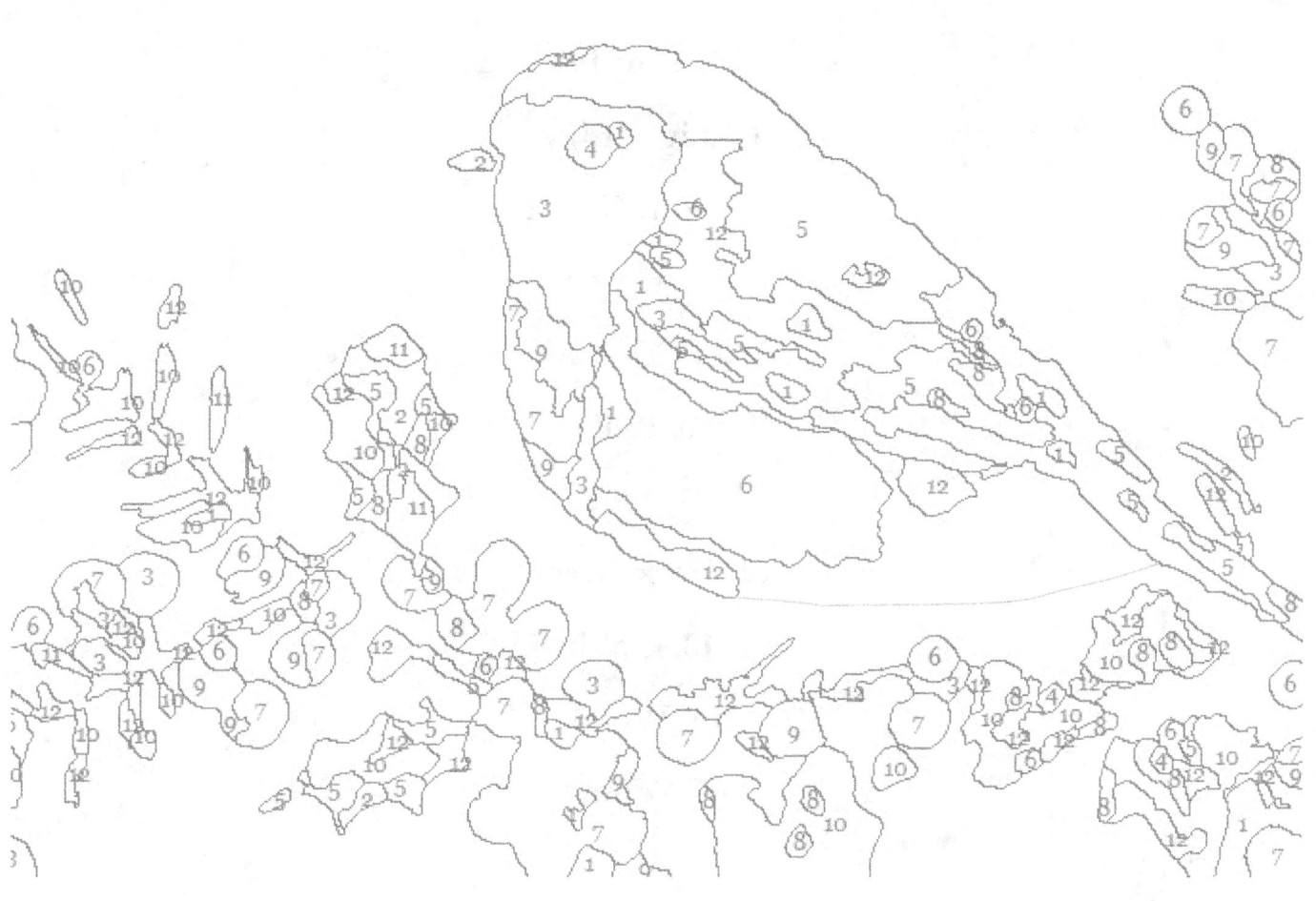

1. Black
2. Green
3. Blue
4. Brown
5. Purple
6. Light Blue
7. Light Green
8. Orange
9. Dark Red
10. Pink
11. Red
12. Dark Green
13. Gold
14. Violet
15. Yellow

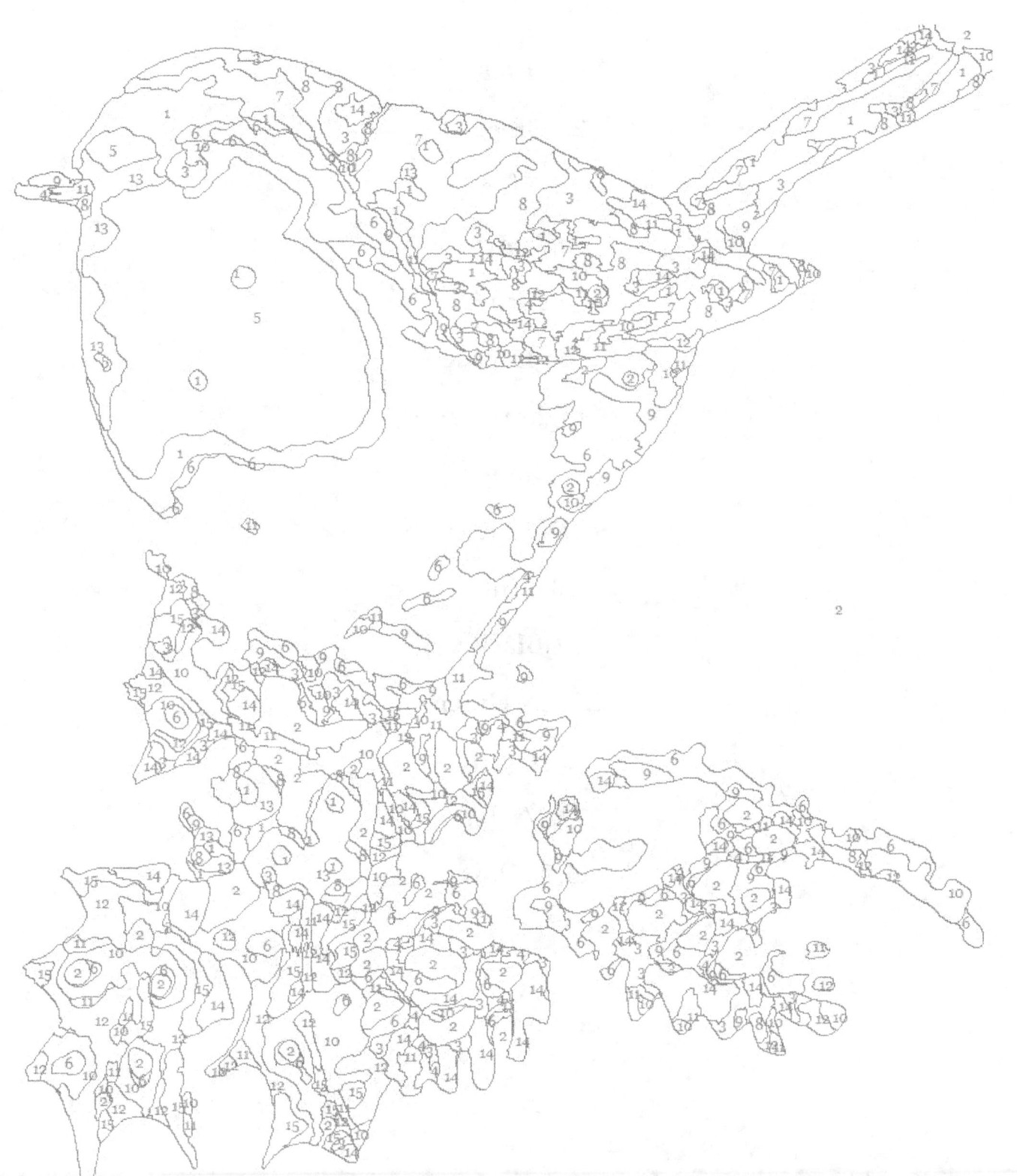

1. Red
2. Green
3. Blue
4. Brown
5. Purple
6. Light Blue
7. Light Green
8. Orange
9. Dark Red
10. Pink
11. Black
12. Dark Green
13. Gold
14. Violet
15. Yellow

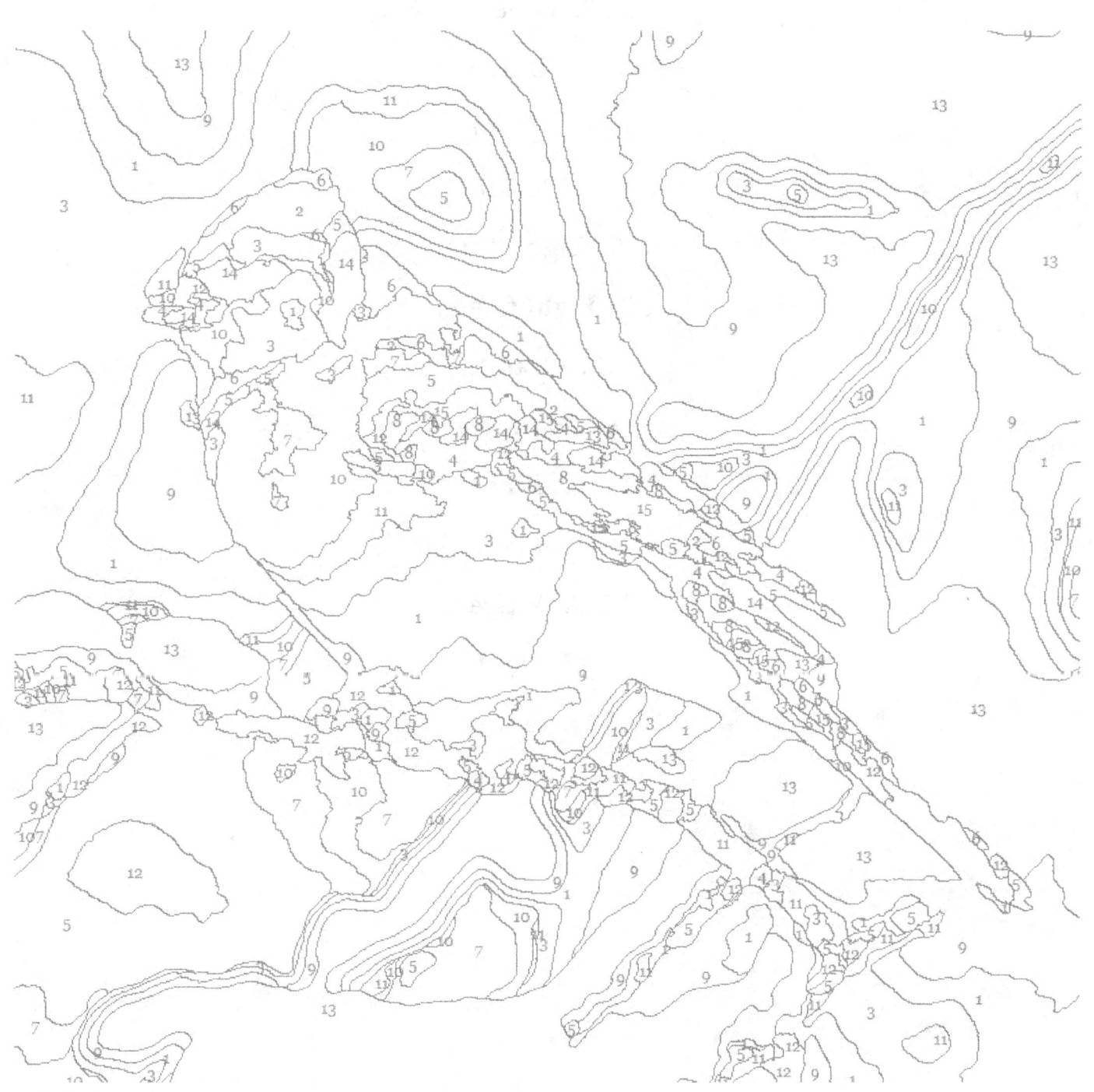

1. Red
2. Green
3. Blue
4. Brown
5. Purple
6. Light Blue
7. Light Green
8. Orange
9. Dark Red
10. Pink
11. Black
12. Dark Green
13. Gold
14. Violet
15. Yellow

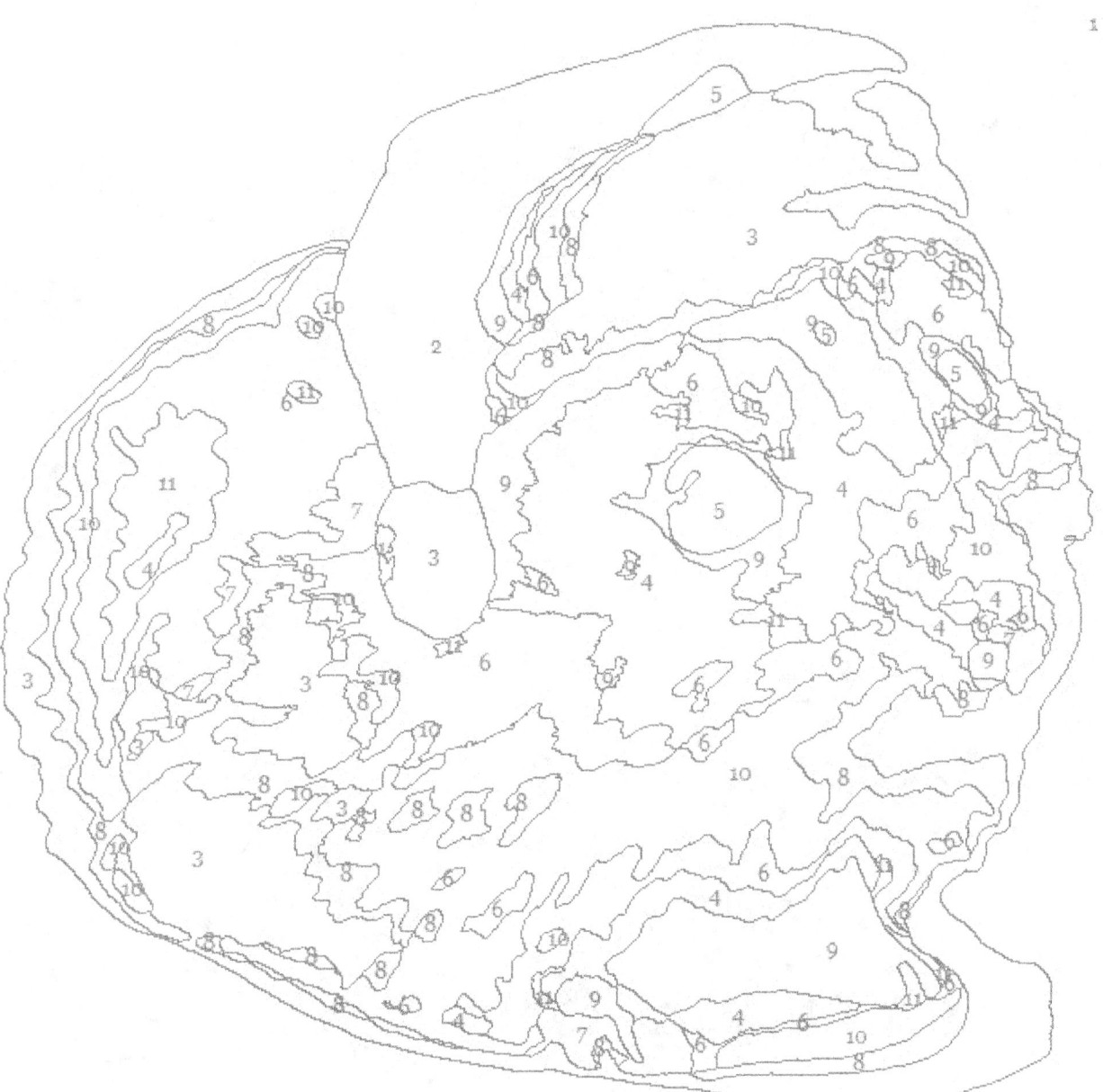

Bonus Dot to Dot Christmas Puzzles

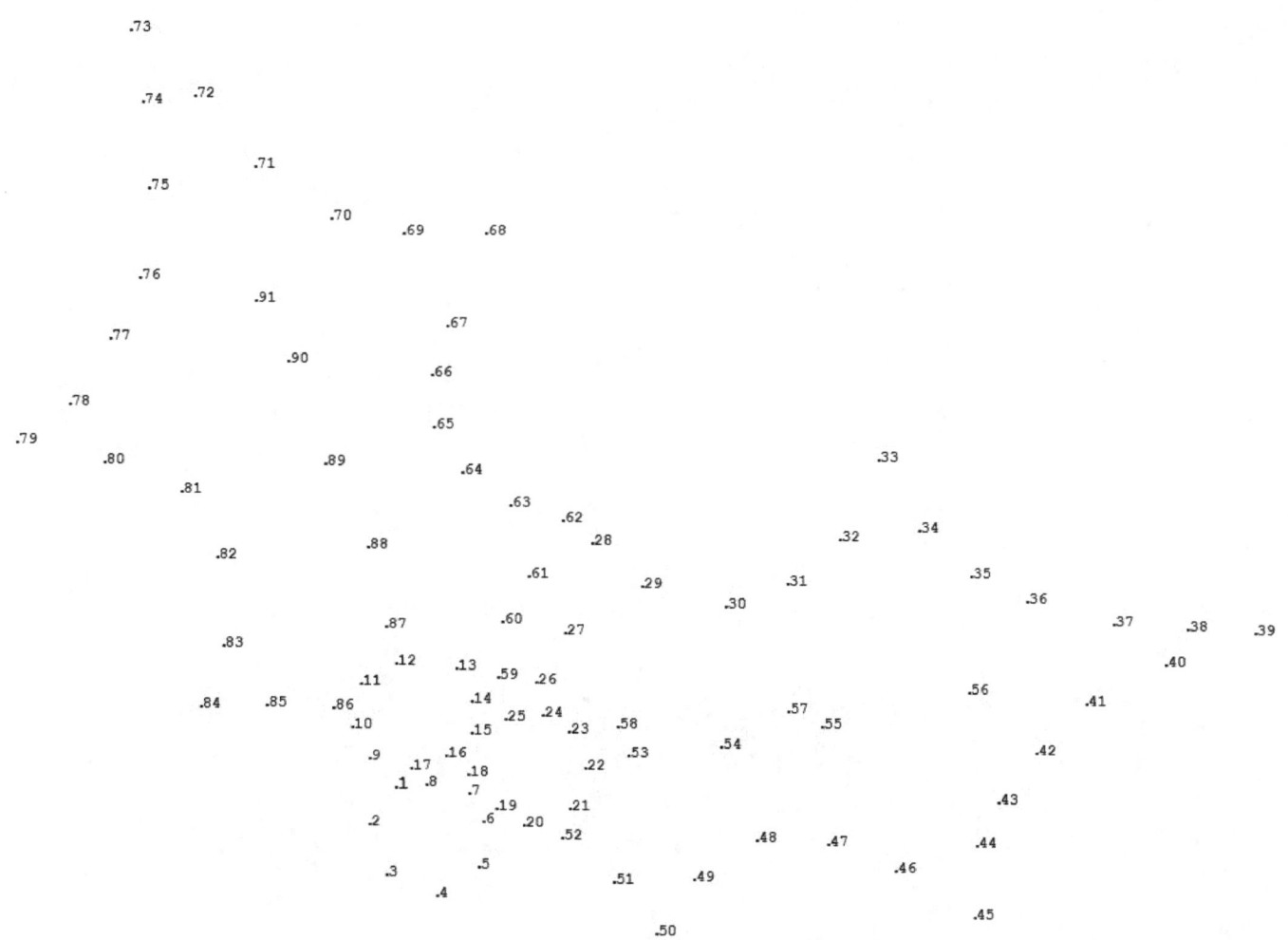

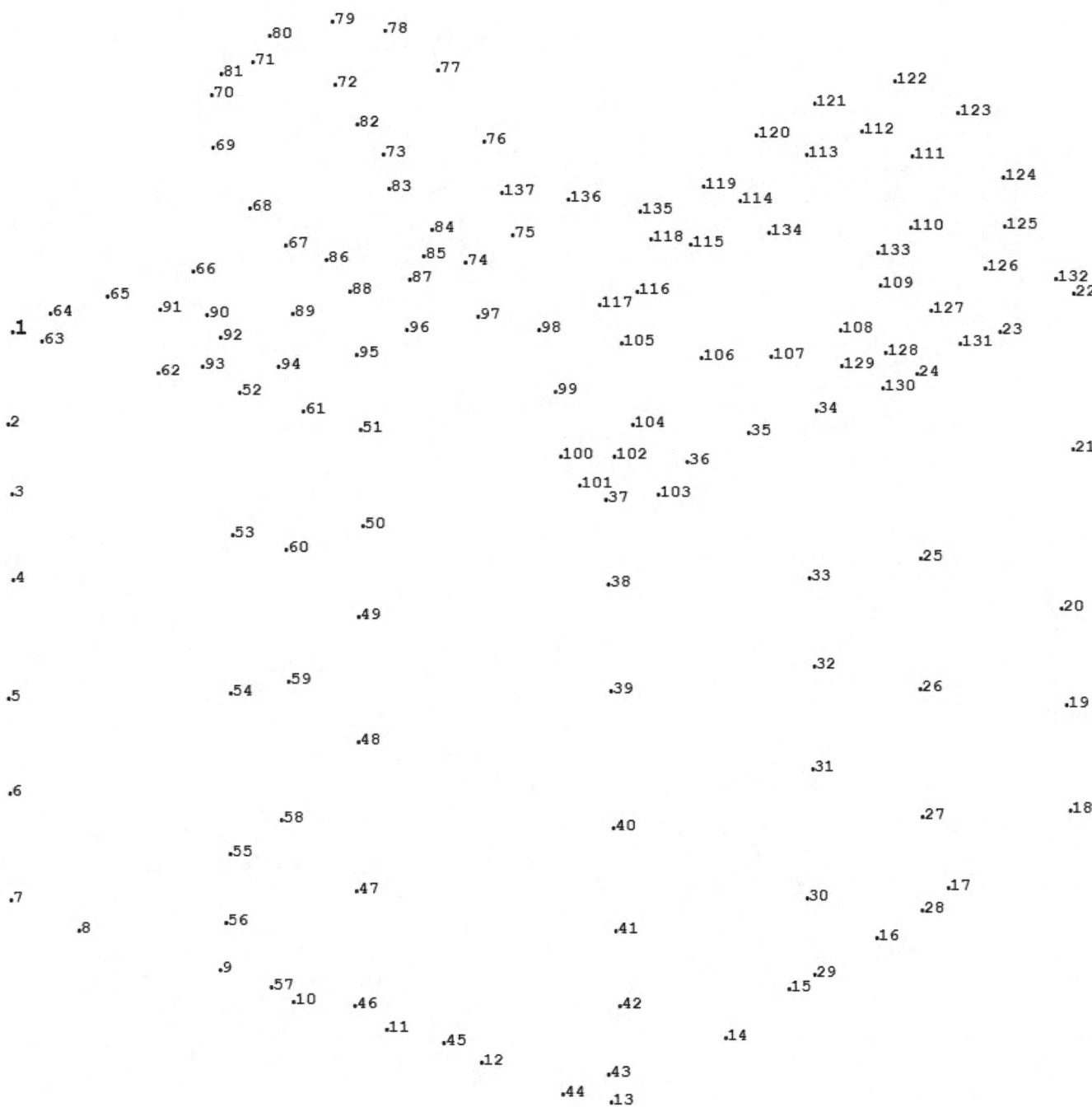

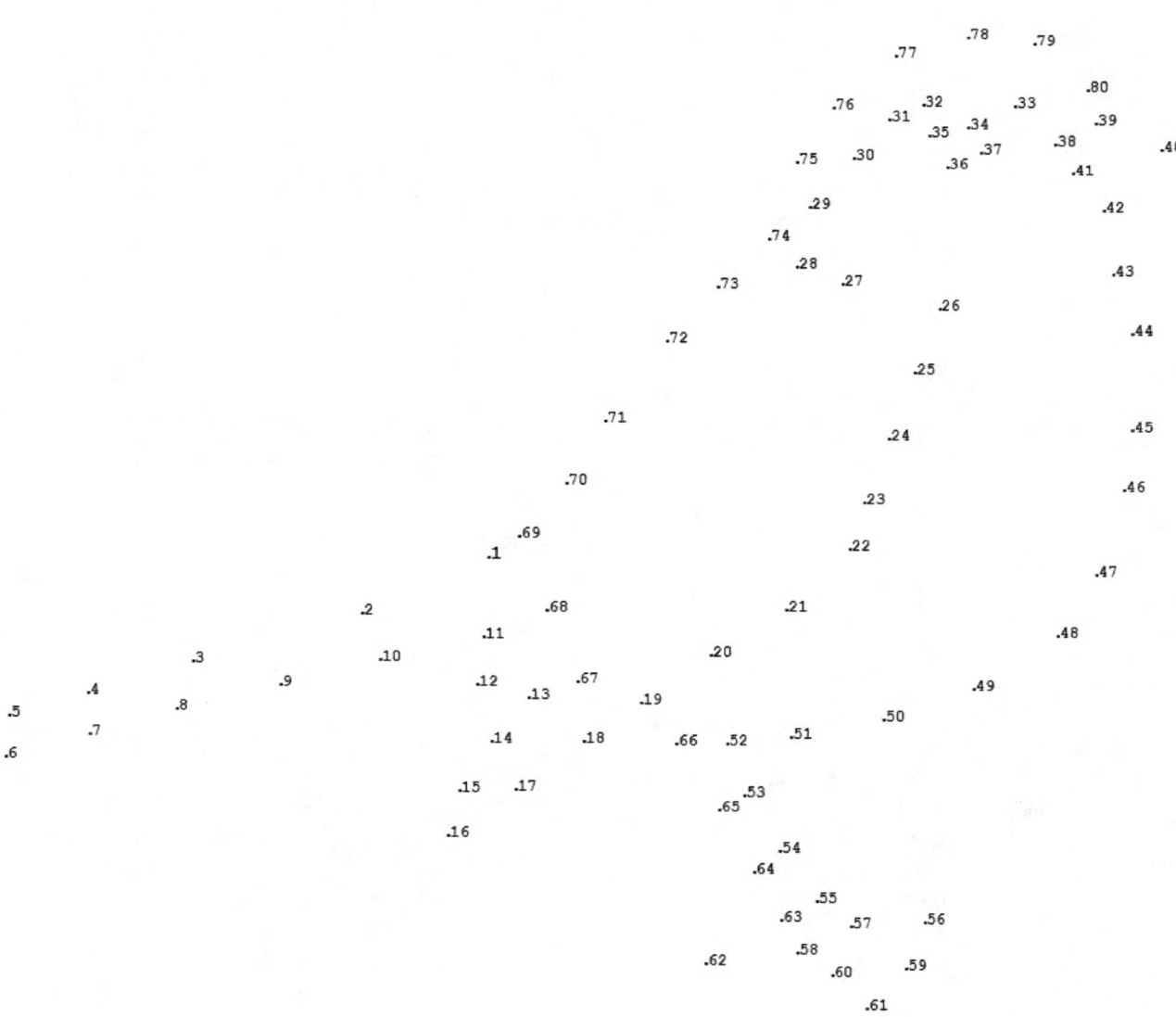

www.ingramcontent.com/pod-product-compliance
Lightning Source LLC
Chambersburg PA
CBHW080910220526
45466CB00011BA/3540